IMAGES
of America

MONTGOMERY COUNTY

Pictured is Gen. Richard Montgomery, a Revolutionary War hero for whom the county was named.

On the cover: The Stanton and Red Oak teams are playing ball during Stanton Baseball Day at Anderson Park about 1949. Clayton Johnson of Stanton is at bat, the catcher is Red Berglund of Red Oak, and the umpire is George L. Magerkurth. (Courtesy of the Montgomery County Historical Society and the Red Oak Express.)

IMAGES
of America

MONTGOMERY COUNTY

S. M. Senden

ARCADIA
PUBLISHING

Copyright © 2009 by S. M. Senden
ISBN 978-0-7385-7719-7

Published by Arcadia Publishing
Charleston SC, Chicago IL, Portsmouth NH, San Francisco CA

Printed in the United States of America

Library of Congress Control Number: 2009928538

For all general information contact Arcadia Publishing at:
Telephone 843-853-2070
Fax 843-853-0044
E-mail sales@arcadiapublishing.com
For customer service and orders:
Toll-Free 1-888-313-2665

Visit us on the Internet at www.arcadiapublishing.com

This book is dedicated to all those who have been fortunate enough to call Montgomery County their home—past, present, and future.

Contents

Acknowledgments		6
Introduction		7
1.	Frankfort Township	9
2.	Lincoln Township	19
3.	Sherman Township	27
4.	Pilot Grove Township	45
5.	Douglas Township	49
6.	Washington Township	73
7.	Garfield Township	79
8.	West Township	85
9.	Grant Township	91
10.	Scott Township	97
11.	East Township	105
12.	Red Oak Township	119

Acknowledgments

The statements contained herein are based in facts gathered through memoirs, interviews, newspaper articles, and records of the period; often there was more than one date or story about some point in history and they did not always agree. There was such a wealth of history and events through the years that it was not easy to fit everything in. Forgive me if I have omitted your favorite story, person, place, or memory. I would like to express my appreciation to all those who helped make this book possible, including the Montgomery County Historical Society, the Swedish Cultural Heritage Center, the Villisca Historical Society, the *Red Oak Express*, and all photographers and storytellers of Montgomery County who were good enough to record their memories. Special thanks to Roy Marshall, Ted Gerstle, John Pearson, and all those I worked with at Arcadia and to Brad for his never failing love and support.

Unless otherwise noted, all images appear courtesy of the Montgomery County Historical Society.

INTRODUCTION

Iowa was a part of the Louisiana Purchase in 1803, but the area was closed to white settlers until the end of the Black Hawk War in 1832. In 1836, the government relocated the Iowa Nation, who had lived on the land for generations, to a reservation so that the eastern part of the territory might be settled. It was from these people that the name of the territory was given.

In 1837, the United Stated moved the Potawatomi, Chippewa, and Ottawa Nations to southwest Iowa. The Potawatomi, led peacefully by Billy Caldwell, left the village of Chicago, resettled into five villages in the Council Bluffs area, and traveled through what was to become Montgomery County. Eastern Iowans considered western Iowa to be a vast, mysterious wilderness, peopled thickly with vague and dreadful phantoms of imaginary uninhabitableness and that the area would never be worth anything.

Before the 1830s, few white people had traveled across the vast prairie of tall grasses, meandering rivers, and thick groves of oaks, black walnuts, and cottonwood trees that grew in the deep, fertile soil. Gentle, rolling hills with stunningly beautiful vistas stretched out between the Mississippi and Missouri Rivers, and wild game was plentiful. The Omaha and Otoe people camped on the Missouri River hunted in this land, but there is no evidence of permanent settlement inland.

In 1846, the Potawatomi sold their land and moved across the Missouri River into Nebraska. On Monday, December 28, 1846, Iowa became the 29th state admitted into the Union. Montgomery County was surveyed in 1851, was taken from the provisional county of Potawatomi, and was attached to Adams County as civil townships for elections, judicial, and revenue purposes. Montgomery County officially became a county in 1853.

Montgomery County was name for Gen. Richard Montgomery, who died in the assault on Quebec in 1775. Born on December 2, 1738, in Ireland, he served in the British army, fighting in the French and Indian War. He was then stationed at Fort Detroit during Pontiac's rebellion, and then he went back to England. In 1773, he returned to the colonies, married Janet Livingston, and farmed the land. Montgomery took up the patriot cause when the Revolutionary War erupted. He was elected to the New York Provincial Congress in May 1775. In June, he was commissioned as a general in the Continental army during the Revolutionary War. While in New York, George Washington appointed Montgomery as deputy commander under Philip Schuyler, but in September, Schuyler became too ill to finish the invasion of Canada, and Montgomery took command.

He captured Fort St. Johns and Montreal in November 1777, and then he went on to Quebec where he was killed during the battle, receiving grapeshot through the head and both thighs.

With Montgomery's death, Benedict Arnold assumed command of the American Colonial forces. Washington was devastated upon hearing of his death, and on January 25, 1776, Congress approved the establishment of a monument in Montgomery's memory. As a lasting legacy, dozens of counties and cities have been named for him. Some of his decedents who lived in this county were Mrs. Smith McPherson, Ella B. Young, and Mrs. A. C. Hinchman.

The first election in the county was held at the home of Amos Lowe in what is now Jackson Township. The first settlement was in Jackson Township, now known as East Township. The first town was named Rossville, laid out by Hiram Harlow on April 28, 1855, but there are no records that survive as to what section it was to be located, and it never materialized into a town.

Early records are contradictory about the exact dates for the establishment of the townships created in Montgomery County; they also disagree about the date of the first marriage between Frank Findley and Margaret Means. One gives the date as 1853, and another lists it as July 1854.

The first schoolhouse in the county was built in 1853 by John Ross in section 26, southeast of Villisca. It was made of local lumber, cottonwood logs, and was paid for by subscription, costing $80. In this school building, the first religious services were held, with Rev. W. C. Means of the Cumberland Presbyterian faith officiating.

In 1865, James P. Ross taught in the third school for a term of six months with the salary of $18 per month. There were 25 scholars who traveled up to three miles to attend. Baker, McMillian, Means, Carslile, Findley, Harlow, Moore, and Penwell were some of the last names of the original students in the school.

The first recorded deaths in the township were that of Mrs. Frank Haeffich and an infant in June 1854. She was buried with her child in a wagon box. Who Haeffich was, where she was going, where she was from, and how they died is left to speculation. A memorial marker has been placed at her grave in the northeast corner section of the township.

The history of Montgomery County is written in the struggles, the passions, the hopes, and the vision of those people who have lived in the county through the years. New generations face different struggles than their ancestors, but each person makes a contribution to the ongoing history of Montgomery County.

One

Frankfort Township

The early history of Frankfort is interwoven into the surrounding townships. Boundaries were drawn and redrawn a number of times over the years until they settled into their current borders. Judge A. G. Lowe made an official order naming Frankfort after his beloved home in Kentucky, designating it as the seat of justice. Frankfort was situated on a small rise that ultimately doomed it to obscurity. When the route was chosen for the railroad, that grade was too steep for trains to climb.

Before 1860, business was conducted by the county judge, but the Eighth General Assembly passed an act on March 22, 1860, which took effect on July 4, 1860, creating the county board of supervisors. The first meeting of such board in Montgomery County occurred at Frankfort on January 7, 1861, when the following members appeared representing their townships: Daniel Stennett (Frankfort), S. S. Purcell (Red Oak), Thomas Moore (Jackson), Isaac Conner (Washington), James M. Christopher (Douglas), and William A. Mahan (West).

The rivalry between Frankfort and Red Oak Junction was one of refinement and culture as well as claim for the county seat. Frankfort was becoming known for its high level of culture and learning, and Red Oak was working on a reputation as a reckless, wild town, second only to Deadwood. Sometimes there were as many as 40 fights in a day there, and all the saloons did a brisk business.

The decision about the county seat was put to the vote. There was a dispute over the counting of all ballots. Ballots with only Red Oak were disqualified until a writ of mandamus was filed by a Mr. Campbell; all the ballots with Red Oak as well as Red Oak Junction were counted. The final canvass of votes on the removal of the county seat from Frankfort to Red Oak was made on June 8, 1864. Red Oak Junction won, and Frankfort began to descend into oblivion. Frankfort was reluctant to release the symbol of its power, the courthouse, and after the building was taken to Red Oak, others were removed or fell into disrepair in the years following, and the hillock that once was so full of promise returned to wild prairie.

This map, from the 1875 Andreas Atlas of Iowa, illustrates Montgomery County, its townships, and its land holdings.

Before the white man came to settle in the lands of Montgomery County, the people of the Iowa Nation roamed these prairies. The Omaha and Otoe hunted and fished, and the Potawatomi were given the land for resettlement when they left the area that was the growing settlement of Chicago. A few years after, they sold the land back to the government and returned to hunt and fish, but soon they were seen no more.

Frankfort was the original seat of government for Montgomery County, serving from 1854 to 1865. This plat map of Frankfort is from December 1866 before the courthouse was removed. In 1881, this was written about Frankfort: "There was a peculiar charm about the small cluster of houses huddled together on a summit showing against the distant horizon. At first sight they appear as a citadel, but dissolves into a row of four buildings fronting east and in what was designated as the town square was a flagpole. Now there is nothing but a distant memory of the town."

This was the first law office in the county. It was built at Frankfort in 1857, and the lumber was hauled from Council Bluffs by oxen. After the courthouse was removed to Red Oak Junction in 1866, this building was used as a cob shed. This photograph was taken by Earl Bond when he learned it was to be torn down. (Courtesy of Wayne and Mary Donohue.)

The first official courthouse for Montgomery County was built in Frankfort in the summer of 1856 by H. C. Shank. It was sold to the county in 1857 for $1,500. When Red Oak became the county seat in 1866, a group of Frankfort men went to steal it. A blizzard forced them to abandon their endeavors, and the courthouse slid down a hill. They brought it to Red Oak and placed it on the square.

Growing young families came to settle this new county, with a strong belief in the future. They came in wagon trains with all their worldly possessions packed into the small space. With dreams of a better life, these people built farms and towns with their strength, hope, courage, and tenacity.

Wagons were the common mode of transport before the train tracks were laid and the iron horse steamed into the county. Often people would live in their wagon until they could build a home. Before the sawmills were built on the rivers, lumber came from places like Council Bluffs on the Missouri River.

Here is the Arlington Mill and dam. Early on, mills became a necessity to sustain settlers. The mills were powered by waterwheels, which were used to grind corn and wheat or to plane lumber for buildings with an up-and-down saw. This work was slow before mills were fitted out with steam power to make the job easier and faster.

The two-horse Jerky was one of many coaches used in early travel. On July 1, 1858, the Western Stage Line began daily service, which ran until November 4, 1869, when the trains replaced slower, outmoded stagecoaches. For many years, the stages were stored in a barn. Over the years, they were given away. This one was given to the Iowa State Historical Society in 1900 and is on display in Des Moines.

Col. Alfred Hebard was commissioned by the railroad to do a topographical survey for a route beginning in Burlington to the junction of the Platt and Missouri Rivers where the train would cross into Nebraska. Frankfort was situated on a hillock that was too steep a grade for the trains of that era to climb, causing the rail line to bypass the town as a stopping place. It was a sentence of death for the small settlement.

On October 18, 1870, Montgomery County sold all the interest in the town of Frankfort to J. R. Horton, who made the highest bid at the public sale for the sum of $312. The town plat of Frankfort was entirely vacated and converted into a farm. As of 1881, there was still a schoolhouse, and the cemetery of the extinct town was still used as a neighborhood burying ground.

Once it was vacated, Frankfort Township primarily consisted of farms. There were schools and country stores for the residents. This is the Frankfort Wallin No. 1 school. It was a one-room country schoolhouse that served the local farming population for many years. This photograph was taken in the 1940s.

The Wallin store served the neighborhood along with the Wallin schoolhouse. This photograph was taken about 1900, but the names of the people were not recorded. With the advent of the railroad, automobiles, and better roads, small settlements and stores held on for a while, but they soon disappeared. Small, one-room schools were consolidated with larger populations.

This rare certificate is from the Flora Town Company, which was a dream that never materialized. Charles Bolt purchased this share on April 11, 1859, which was signed by secretary J. B. Packard and president J. R. Warton. Many towns were planned but never came into being, and others that began as small settlements slipped into obscurity with the coming of the railroad. (Courtesy of Charles Richards.)

In 1948, the Women's Federated Club of Montgomery County placed a plaque on the site of what had been the town of Frankfort, commemorating it as the first county seat from 1854 to 1869.

18

Two

Lincoln Township

Lincoln Township was settled primarily by the Welsh. The first Welshmen to come to the area were Benjamin Thomas, David Harris, and William Harris in the spring of 1855. The first recorded deed of sale for land was in 1869, when 240 acres at $1.75 each sold to Thomas. On January 8 and 9, 1868, the county board set off three new civil townships and named them Grant, Lincoln, and Sherman. The first election was to be held at the Pilot Grove schoolhouse at the usual time of fall elections.

In 1870, John Davis and John E. Wood arrived, followed in the next year by Henry Thomas, John G. Jones, William T. Edwards, Griff J. Jones, Griff Thomas, and others. They called their settlement Wales, and the average population remained about 40 souls over the years. Farming was the primary occupation in the township.

In 1876, two churches, Congregational and Presbyterian, were built. These churches grew quickly and were a central part of life in the township. In 1947, the Congregational church was closed and dismantled as the people agreed it was not financially possible to support two churches.

In 1891, Evans T. Evans built a cheese factory outside of the town and had a large export business that shipped all over America until it closed in 1903.

A one-room schoolhouse was built in 1876 and was used until 1917 when it was voted to consolidate the schools. A new school building was constructed on that site for both lower grades and high school. Felix Netcell drove a school bus for 32 consecutive years, and he never had an accident. In 1949, plans were drawn up to build a new gymnasium. It was completed in 1950 and was also used as a community center.

William B. Hughes built and operated a country store that grew over the years and was known as the Wales Store. It was the town gathering place, especially on Saturday nights for cards and good conversation on the south porch. There was always a big pot of coffee and either cookies or ice cream depending on the season. This fellowship continued until World War II.

A group of people pose in front of the Wales Store in 1890 proudly showing off their best, including the latest in bicycles. William Hughes built a little store to serve the area that was called the Wales Store. The lumber to build this first store was brought on wagons from Omaha. Over the years the store was enlarged and modernized.

The Wales store was a central gathering place for generations. One-stop shopping was available for the residents of the area; one could get their supplies, groceries, and fill up their vehicle at the Wales gasoline station. Clarence Wedell was a popular owner of the store, though of Swedish descent, he was affectionately called the "Prince of Wales."

Farmers in the community worked together at harvest time to bring in the crops. This photograph was taken around 1890 of a threshing crew working on the John G. Jones farm at the southern edge of Wales. The threshing machine was operated by Bill Buehler.

At the Wales Community Church, faith was a strong and central part of the congregation. The Presbyterian church became the Wales Community Church when the Congregational church was dismantled in 1947.

Students stand in front of the first Wales schoolhouse in 1900. The teacher is Sam Price, and some of the students are Dave Jenkins, Lew Jones, Morris Evens, Clement Jones, Ted Owens, Ed Wood, Lizzie Jenkins, Annie Jones Johnson, Nell Jenkins Geopfarth, and Mary Wood Cooper. When the new school was built, the old one was moved a short distance and served as the bus barn until it burned down and was replaced.

A group of young children pose with their teacher about 1915.

The Wales schools were consolidated by 1920s. This was the Wales-Lincoln schoolhouse in 1929. There were four busses to transport rural students. They were GWW trucks manufactured by George Wilson Company in Henderson. The busses were very slow in speed but were considered powerful in their day; they were excellent on the muddy roads and high snowdrifts. Felix Netcell, far left, was a driver who never had an accident in the 32 years he drove.

Lincoln Wales Consolidated School classmates pose on the steps of the school in 1930. Clifford Vestall and Mabel Lane were both teachers, and the superintendent was Mr. Harkness. Lane is second from right in the back row.

Gertrude Davis (McLain) and Letha Rossell (Dahl) pose on the steps with Wilber James, one of the teachers at the Wales school in 1929.

Here is the Wales-Lincoln brass band in April 1942.

Also pictured in April 1942 is the Wales-Lincoln band.

Here are the Wales-Lincoln seniors in 1942.

25

The Wales area continues to be a farming community. Farming today is easier than it was a century ago. Pictured in the 1890s, a man sits on the platform by the windmill, a source of power that pumped water from the well. Other family members stand on the ground below.

Wales consisted mainly of farmers who tilled the rich soil, producing excellent crops of wheat and corn. An unidentified man stands in the field at harvest.

Three

SHERMAN TOWNSHIP

On January 9, 1868, the county board of supervisors created the townships of Sherman, Lincoln, and Grant. Sherman was organized on April 12, 1869, and Wayne Stennett was named trustee. The settlements of Stratton, Elliott, and Stennett became the major centers of commerce.

Henry Kneedy and William Baker came to what would become Stratton in 1870. Kneedy taught in the first school in his home. It was soon too small, and a school was built that became the community center where a literary society also held meetings. The school hosted the first religious services.

In July 1878, Charles Elliott Perkins, a trustee with the Chicago, Burlington and Quincy Railroad, purchased 160 acres from Ed Gilmore for $3,700. By October 18, 1879, Anselmo B. Smith surveyed and platted the land for the town of Elliott, named for Perkins. Elliott was on the branch line from Red Oak to Griswold, connecting to a branch of the Chicago, Rock Island and Pacific Railroad to Atlantic. By January 1880, there were 30 business and 20 houses in Elliott. About 300 people were living there, and Elliott was still growing. The old house that had been the Gilmores' was where the first school was conducted, as well as the first worship services. This house was later razed, and the Christian church was built on the site.

There was an effort to move the town of Elliott half a mile east to higher ground, but it never happened. After World War II, a dike was built around the west part of town to protect it from floods.

Stennett was created from the vast land holdings of Wayne Stennett, who originally came to the area from Muscatine in 1856. He returned with his family to settle permanently in July 1858, arriving with a mover's wagon drawn by a team of oxen and two covered wagons. Originally he was one of the largest landowners in the county, with over 1,000 acres. The settlement became a busy trading post. Nearby on the Nishnabotna River, there were two gristmills utilizing waterpower to grind the flour.

Stratton church was built in 1890. Services for the growing community were held in the schoolhouse, and William Yockey, Mr. Bourne, A. C. Rawls, and L. C. Stratton were some of the early preachers. It was Stratton who organized a Methodist Episcopal church in 1889. William Baker donated the land for the church, and on August 17, 1890, Reverend Stuart delivered the dedicatory sermon.

On Sunday May 9, 1913, lightning struck the church, burning it to the ground. The next day, as the ruins were still smoldering, sufficient subscriptions were pledged to rebuild. Before the next Sunday, a tabernacle was built across the road in the schoolyard, and the new church was being built. Here, members gather in front of their church at the tabernacle in 1913.

The Stratton church was dedicated on December 7, 1913, and continued to be central to its members. This photograph was taken in 2007.

Here is Prairie School No. 9 in 1931. Ethel Gasson Pettison is the teacher seated at her desk. Pictured from left to right are (first row) Vernon Larson, Faye Peterson, Muriel Gustafson, and Mary Houser; (second row) Wayne Kirby and Ferne Gasson. The school began prior to 1875 and was closed from the fall of 1937 through spring of 1945. It was last used during the 1953–1954 school year. Elmer Lindgren was one of the men who bought it at auction and salvaged the lumber from the old school.

29

Seen here is a T&K Evans grain train. Elliott had a Chicago, Burlington and Quincy Railroad depot. The first depot agent was John Danielson. Two passenger trains came from Red Oak each day. There were usually two passenger cars needed to accommodate the business travelers. Passenger service was discontinued around 1959, but the freight trains still ran three times a week. The track washed out often when the Nishnabotna River flooded. Trains would often slow down so fishermen could get off an on by the river. The Tornado Saloon was located next door

T. E. Grace was the proprietor of the Hotel Grace. On January 10, 1893, he committed suicide. His wife was accused of murder by his brother but later found to be innocent in a trial in Red Oak. Elliott House was the first hotel in town, operated by W. J. Petty.

The first bank in Elliott was established in 1881 by H. M. Murer in a wooden building. It was soon replaced by the first brick building in Elliott. H. E. and J. J. Manker opened a bank in 1884. In 1903, the First National Bank opened.

The first newspaper in Elliott was the *Enterprise*, and O. C. Bates was the editor. The *Enterprise* was printed for two months, was suspended for two months, and went out of print in 1881. The *Reporter* began in September 1884 and closed in 1885. In January 1887, Professor Montgomery, editor of the *Graphic*, purchased the old Reporter building for $100. In 1893, the *Graphic* ruled out tobacco advertisements, and the use of the word tobacco was only used to condemn the filthy weed.

Pioneer Drug, News and Variety Store was the first building constructed on the town plat by Joseph McClure in October 1879. Due to illness, he did not officially open until January 1880. McClure was appointed postmaster in July 1880 even though I. H. Page had been postmaster previously. Later the drugstore was operated by Charles Berty Halbert. Here, Halbert and his family stand on the steps in 1896 with two unidentified men on the boardwalk.

Real estate was a booming business, and the town grew quickly. Between January and the fall of 1880, 30 businesses and 20 homes were built in the growing settlement. In 1899, the average price of land per acre in the township was $46. Pictured is the first bank erected, which was moved when H. M. Murer constructed the first brick building in town. By the summer of 1916, there was a strong movement to replace all frame buildings with brick ones.

In the paper in 1886, it was claimed that there were no saloons in town; however, persons were seen wending their way through alleys with strange-looking parcels and heavily laden valises. Some say that certain persons pay $20 per month for the privilege of being left alone. Warman and Company were the proprietors of the Cyclone billiard hall, which had many fine pool tables and served Milwaukee beer, native wines, mineral water, and lemonade.

Here is the Wood's Opera House. The opening of the Elliott opera house on January 8, 1897, was a great success. Three nights of performances brought in net proceeds of $117.90, most of which went to defray the cost of the hall and to pay the Elliott band.

On May 30, 1870, Isaac H. Page applied to Washington, D.C., for a post office to be called Wilson and located in section six of Sherman Township. The Elliott Post Office was officially recognized as being in service on October 21, 1879, and Page moved it to a corner on Main Street in Elliott. He was the first postmaster and a pioneer merchant. When Joseph Clure was appointed postmaster in 1880, the post office was moved to the drugstore.

A group of people gather to witness the first rural free mail delivery wagon out of Elliott. At the end of the first month, C. M. Kneedy of rural delivery reported that he delivered some 4,770 pieces of mail and collected 757. At the close of 1907, Elliott became a third-class post office.

Here are the Palace Livery and Amos Smith Livery in 1908. The Palace Livery barn was conveniently located only two-and-a-half blocks from the depot. It was owned by J. M. Roberts and was considered to be up to date in every way, according to an article written in 1904. The building was 60 by 100 feet, with a carriage room measuring 24 by 70 feet. There was a good-sized space for washing buggies and horses with a neat little office and a sleeping room for the night man. The harness room and the pump room each measured 10 by 12 feet.

In 1918, Armistice Day celebrated the end of World War I with patriotism and a parade. The citizens of Elliott turned out at the depot to welcome home their war hero, Tom Gray.

Charles Vannordstrand and H. R. Hillhouse are seen at their grain elevator. On December 31, 1901, B. C. Ragan's grain elevator near the depot was destroyed by fire. In 1879, wheat was being sold at 90 for $1, corn was 24 for 25¢, rye was 65¢, and hogs were $3.50. In 1885, Elliott was shipping more corn than any other town in the county.

In November 1947, the Kipp Brothers feed and seeds, grain and coal, and grain elevator were sold. In 1889, there were 769 cars of freight shipped from Elliott, including 340 of livestock and 318 of grain.

Dr. Charles S. Wood stands in front of his veterinary office in Elliott about 1904. With him are his two grandsons, Scott Wood and J. S. "Tim" Wood. This building was located on the north side of Main Street a little west of the depot. The other boys in the photograph are unidentified.

A postcard depicts a happy group taking a hayrack ride near Elliott.

Here is Old Watson Mill on the Nishanbotna River near Stennett. Mills were very important to early settlers. This was where flour was ground so staples like bread could be made. Sometimes pioneers stranded in winter and unable to get to the mill would have to use a coffee grinder to make flour.

Seeley Flowering Mills, previously the Stennett mill, is pictured here. In the foreground is the Davis Mill Road. Mills were built upon the water to harness it, turning the waterwheel and thus the gears to grind the millstones. Later steam powered the mills, and grinding went much faster.

Here is a Log Cabin near Stennett. These were made of hewn logs from indigenous trees, walnut being one of the most common. Other common trees were the red oak and the cottonwood. When larger homes were built, many of these log cabins were converted to storage sheds, and then all too often, these early homes were left to fall apart and were set afire. This one no longer exists.

In the Stennett area, limestone was available. It was quarried to build homes, schools, and stores. This photograph is of the Works Progress Administration rock quarry.

Wayne Stennett built this large 12-room house in 1869 of locally quarried limestone. The walls above ground were 18 inches thick, and the walls in the basement were nearly 30 inches thick. The interior was finished in walnut. This house was considered to be a palace when it was built. Over the front door, a glass panel was installed with "W. Stennett" etched into it.

Near Wayne Stennett's stone house was the schoolhouse that was also built of the local limestone. It served as the first town hall. Much later, this school was converted into a residence; however, the place was eventually abandoned because the river flooded so frequently. By the time this photograph was taken in the 1950s, the building was deteriorating.

Stennett's General Merchandise store was built in 1880 of native limestone. It was an early landmark. Owned by Floyd Baker, it sold groceries, general household items, and farm wares and was the only store in the Stennett community. In March 1949, it caught fire and was completely gutted. Around 1950, the community consisted of a lumberyard, a grocery store with a hand gasoline pump out front, a post office, a church, a blacksmith, and 12 houses.

Built in the spring of 1880 for Henry Light by Jesse Fate, the Stennett's General Merchandise store once was the hub of an enterprising village. Light was the first postmaster who operated the store for several years. Several owners later, in 1904, it was sold to Walter Draper, who was also a postmaster, the station agent, the mayor, and a hog and grain buyer. Later it was owned by a farmer's mercantile, consisting of Leonard Carslile, Tom Ballard, L. Hughes, Hank Ellis, and the owner at the time of the fire, Floyd Baker.

Jason B. Packard was born in 1815 and came to Iowa in 1856 with his wife and two small sons, settling on a farm near what was Frankfort. The land was awarded to his wife's father for his service in the War of 1812. Packard served as county treasurer. He kept papers and money in the commodious pockets of his coat and was never a penny short.

For many years, Packard was the only newspaper correspondent in the county. He wrote a commentary on the Lincoln-Douglass debates in Illinois in 1858 and sent a copy to Abraham Lincoln. Lincoln responded, "Dear Sir, Yours of the 11th with the article on territory for convicts is received. It presents a new idea, and I shall consider it. I fear you will not get Douglass to avail himself of your assistance. At all events your skirts are clear. Yours Truly, A. Lincoln."

Packard admired Henry David Thoreau, and he insisted that houses were built more for show than comfort. Living in a log cabin near Frankfort, he excavated a 20-foot-square area down to the cap rock near the Old Watson Mill, north of Stennett. He built a house of the most unusual architecture in the county. Octagonal houses were popular in the 1850s. He chose to build one, which had six sides that were 21 feet long and 17 inches thick, each meeting at 120 degrees.

Packard and his wife were book lovers; they read Johann Wolfgang von Goethe, Thomas Carlyle, Thoreau, and Ralph Waldo Emerson. Packard designed and built his house for practicality on the prairie. Set against the slant of a knoll, the house had a door or a window or both on six of its sides. Stairs were not needed, as lumber was expensive; the upper level was entered from the rise of the knoll. The peak is about 19 feet above the floor.

The upper floor of Jason B. Packard's home was suspended by wires that stretched across from side to side, with a space of about a foot being left at the outer edge of the floor to permit heat to ascend to the upper room from a fireplace built into the wall on the lower level. The house was eventually abandoned and left to deteriorate. This is how the house looked in the 1940s. The Charles Richard's family is pictured taking an outing to see the old relic. (Courtesy of Charles Richards.)

The following is a part of Packard's epitaph: "He lived in a world of enchantment but enchantment has given place to reality, and now my fortune is made." In 1950, this was what remained of the distinctive octagonal house. No one thought to preserve this exceptional home. By 2009, only a block or two of the limestone foundation remained buried in the soil. This unique house is only a memory.

Four

Pilot Grove Township

Pilot Grove received its name because of the extensive groves in the area that were landmarks used by the Native Americans and, later, caravans to pilot them across the area. On April 18, 1861, Pilot Grove is mentioned in county records. By 1869, the township was growing in population, and an influx of settlers stayed, as they were unable to cross the Tarkio River, where there was no bridge. They bought land from the railroad, schools, and speculators, paying from $3 to $10 an acre. On September 6, 1870, Pilot Grove was formally named as a civil township. On January 31, 1871, A. B. Milner was allowed $7 as clerk of the township, Briggs Olds was named trustee, and B. L. St. Clair became the assessor.

Some early settlers included John Dodd, whose son was born on December 5, 1850, and John Burnside and L. C. Cook, who came in 1854. Purdy Cook was the first girl born, in April 1858. By 1853, Samuel Coe settled in what was then called Coe's Grove (section 7) near Elliott. A. M. Powell and Jacob Focht came in 1856. In 1861, Focht enlisted in Company F, 160th Regiment. L. B. Fuller came by covered wagon and established a blacksmith shop. He also had a fine racetrack with excellent horses from all over the county and built the first big barn. W. J. Pettit, affectionately referred to as "uncle Jack," came with a yoke of oxen from Wisconsin. He broke the prairie for other settlers and from his earnings was able to purchase his first 60 acres. Edson Buss, who came in 1869 at age nine, recalled that lumber had to be hauled in from Atlantic.

The first marriage was James Penry's in the spring of 1857. Circuit rider A. P. Gilmore held religious meetings at the original Pilot Grove Schoolhouse. Mr. Yockey organized the Pilot Grove Center Methodist Church. He, along with Martha Yockey, Thomas Pettit, George A. Pettit, and Rachel Pettit were members in 1881. By 1885, there were 65 members. In 1886, pledges were given to build a church, dedicated in 1887. In 1878, the United Presbyterian Church of Pilot Grove was organized, with John Askey and family, J. Y. Martin and family, Isaac Barr and family, and J. A. Demming and his wife as founding members. This church was dismantled about 1950.

In this photograph, an old log cabin that tenaciously stood against the elements since the 1850s was relegated to a chicken coop before it was destroyed. Before sawmills were built nearby, the early settlers had to chop the native trees of walnut, red oak, or cottonwood, split them, and build log houses that were very snug. Often large families lived in these houses, and strangers were seldom turned away.

This etching from the 1875 Andreas Atlas of Iowa shows a prosperous Orchard Grove farm. For many years, farmers did not believe that orchards would grow in the area, but in 1870, Thomas Wall and I. H. Page each set out 100 apple trees. By 1880, Wall raised 200 bushels of very fine apples. The population peak in Pilot Grove Township hit 880 in 1880. By 1950, the population was only 489.

A. B. Payne took this photograph of Uncle Ike in 1927. The rugged Montgomery County individual is sitting on the rotting porch of an early frame structure that had weathered many storms. The boards of oak or walnut were planed at the local mill along the Nodaway or Nishnabotna Rivers. This individual had seen the birth of the new county, the battle for the county seat between Red Oak Junction and Frankfort, and the coming of the railroad, electric lights, motorcars, and telephones.

Pilot Grove Township is primarily made up of farms. This is a photograph of a beautiful farm around 1900.

Students are on the steps of the district No. 4 school in Pilot Grove Township. Pictured, in no particular order, are Harold Mellott, Delbert Craig, Marian Milner, Russell Milner, Lee Wright, Bert Thomas, Lloyd Thomas, Gerald Mellott, Hugh Hummell, Hazel Milner, and Opal Mellott.

This was once a school, now it is a residence. The first school stood on J. D. Baird's land and was furnished with split-log desks and benches. By 1881, there were nine ungraded schools in Pilot Grove, six male and three female teachers, 244 pupils with an average attendance of 170, and the tuition cost $1.25 per scholar. In 1920, after much controversy, the Pilot Grove school district consolidated, and by 1945, there were too few students and a scarcity of teachers and schools were closed. By 1953, district No. 9 was the only one of the original school districts with schools still open.

Five

Douglas Township

Morton Mills was a small settlement in the southern part of the county. It was named for the mill built on the river. In 1858, there was a battle between the Potawatomi and Sioux Nations near Morton Mills on the banks of the Nodaway River. Many artifacts were found as farmers tilled the land.

The Nodaway River meanders through the county. Early settlers called it Sixteen Mile Creek, as that was this distance to the Mormon trail. Later it was called by the Native American name that means fordable, or to cross a body of water without a canoe.

Samuel M. Smith arrived and built a mill and a dam to harness the power of the Nodaway River. For many years, the area was called Milford because of a ford at the mill. The name was changed to Grant because there was already another town called Milford.

William Stipe returned from the gold fields of California around 1852 to settle in the northern part of what was to be Douglas Township. When he and his brother David arrived, there were only seven other men in the western part of the county. Government land cost $1.25 an acre. He built the first log schoolhouse 1855.

Other pioneers included Thomas and Electa Sherman Donoho and Allen S. Donoho, whose daughter Elizabeth was the first bride in the new county, marrying Samuel Neeley. On September 28, 1855, Thomas Donoho was the first white male born in the area. R. M. G. Patterson came with his two sons, John W. and Jonathan T., in 1852. John W. Patterson became the first treasurer; he married three times and fathered 10 children. Aaron and Nancy Patterson arrived by covered wagon in 1854. Their daughter Sarah was born on October 4, 1855, and was the first white female born in the county. Benjamin and Sarah Archer arrived in 1854, and the first township elections were held in 1856 in their home.

Milford was growing rapidly. In May 1856, preacher William T. Reed, his wife, Elizabeth, and four children arrived. He was called "uncle Billy." He preached when the circuit rider was serving other communities.

The center part of this old barn in Morton Mills was originally the mill. Buildings were used and reused because lumber was too costly to waste.

Here is Morton Mills Union Church.

William Stipe, whom the Native Americans called "Mr. Bill," built this log cabin in 1853 near the Nodaway River, where there was plenty of timber. It was where he and his wife, Anna Caywood Stipe, raised three children. In 1869, he sold it to the Romig-Miller family, who raised five children in it. When that family built a new house, the cabin was used as a tool shed. In the 1950s, it was moved and fixed up. It fell into disrepair, was restored again, and moved to the grounds of the Montgomery County Historical Society.

This is another photograph of the Stipe cabin still standing on the farm. When it was built, Native Americans still returned to hunt and fish on their old lands, their favorite places being Grant and Arlington. They were friendly to settlers, and their help was invaluable in the beginning. From them, early settlers learned how to live outdoors, pick a good spot to build a home, blaze trails, and live off the land. Frank Archer also had a good friendship with the Native Americans.

OLD MILL SCENE, NEAR GRANT, IOWA.

Samuel M. Smith came to the area in 1856. Smith and Charles Bell built and operated the Milford mill. The timbers were hewn with an adze, it was one story, and it was able to grind corn and saw wood. Water powered the mill. A new mill was built in 1873 and 1874, rising three stories above the basement. The opening was celebrated with a party on all three floors and 200 people in attendance. The mill stood until 1941 when it was torn down.

It was from the mill and the dam that the settlement was named Milford. The big threat to the mill and the dam were high waters from heavy spring rains. Four to five inches could turn the area into a small inland sea. The bridge across the millrace was the responsibility of the mill owner to maintain. In this old photograph of the dam with Milford in the background, the school is the tallest building on the horizon.

The plat of Milford-Grant was filed on June 29, 1858. The plat was purchased by Smith in 1859. Thanks to the sawmill run by Smith, Thomas Donoho was able to build the first frame house. The name of Milford was changed to Grant when it was decided to incorporate, but it was still called Milford for years afterward. Grant was incorporated on March 28, 1912.

This etching of Milford is taken from the Andreas 1875 Atlas of Iowa. Identified in the drawing are the grocery, a general store, a millinery store, a cabinetmaker, a drugstore, Smith's Milford mills, the church, the school, and farms along the Nodaway River. The sign by the wooden bridge indicates that the road leads to Sciola, Quincy, and Villisca.

This was the view from cemetery hill with the old school cupola in the distance. The first burial in the east cemetery was of Anson White, who died in April 1858. In the early days before the sawmill was built, there were shacks and huts of every description scattered over the prairie. There was even a dugout home in the area. These were soon replaced by frame houses.

This old photograph depicts a residential scene of Grant. From left to right, the houses identified belong to Dr. Weirs, Amos Paulbin, Maris M. Cue, Lottie Loomis, and Bert Courcier, and past the last house is the depot. On the horizon is the new school. On the back, this note is written: "And this is a part of Smith's addition. Bert Courcier lives with his mother; Fred and Leila live in their house."

When travelers came to town before there was a hotel, they usually stayed at Samuel M. Smith's 11-room home. James Hart tore down the Allard Store and remodeled the house into the first hotel in 1877. Sometimes still called the Allard House, the Grant Hotel had many owners over the years and finally closed in 1922.

Here is the first soldiers' reunion on Decoration Day in 1910. In the parade are the band, the colors, and the GAR veterans as they come up Main Street, making a turn at what would become Highway 71 to the first Methodist church to the north. In the background is the Allard House (right) and then the 1903 T. R. Westrope General Merchandise store, which burned in about 1915, was rebuilt, and burned again in October. In the extreme rear is the Farmers Savings Bank.

D. Vetter's Department Store was built in 1860 by Dave Vetter. Gus Courcier, the blacksmith, stands on the porch. The first general store was built by Isaac Plaquet in 1854. David and Harriet Allard opened the second store in town in 1860. Their home was later remodeled into the Grant Hotel.

Here is an interior scene of Judson Ashbaugh's store. Ashbaugh is in the center with two unidentified men in his store in Grant. A. J. Ashbaugh built his blacksmith shop in 1875.

MAIN STREET LOOKING WEST GRANT IOWA

Baptist

This is Main Street looking west, and the Baptist church is marked. Grant was a busy and growing town. Mrs. White was the first dressmaker in town, and she also was a tailor. In 1901, George A. Smith built the Masonic hall. He was the first master. While building the hall, he lost his hammer. It was found again in 1938 in a wall by Kenny and Carl Mueller.

This fireproof brick building saw many uses over the years. It was built by Norton Jones, who came to the area with his parents in 1888 when he was six. He worked at various jobs until he became the manager of the Coffee and Irwin Implement House. In 1921, he was able to buy the business. In 1927, after another of Grant's many fires, Jones built this building on Highway 71. It was known as Jones hall, later as the school gymnasium, and finally as the 71 Garage.

The Methodist Episcopal congregation was founded in 1855, and the first sermon given was in the home of Allen Donoho. The first Methodist parsonage built in the county was in Milford in 1867. W. T. Smith was the pastor from 1867 to 1870. Ruth Young stands in front of the parsonage in this 1870 photograph. She was the daughter of the second pastor, Reverend Young.

Looking south to the business district, the Methodist church, Ed Weeks Honey House (bees were his business; he sold honey to the Sue Bee Company), Mueller's Hardware, Wahlund's store, and Bob Wilson's post office are seen. The post office later became Bert Smith's restaurant, but it burned in the fire of 1927.

The Baptist Church Society was organized in 1860. Samuel M. Smith, a Baptist, built a beautiful two-story church. Baptisms of full emersion were held in the river below the dam year-round; in winter, a hole was chipped in the ice. No one ever suffered from their immersion in the freezing water. Many records were lost in the fire that destroyed the church in 1920.

Church was central to the social and spiritual life of the people of Grant. The Methodist Episcopal Church was the first to be founded, then the Baptists, and finally the United Brethren was founded in the early 1890s.

59

Hoyt Newcom and Julia Ellenwood stand in the center of the students in the school yard. The first school was built of logs by William Stipe in 1856, and Miss Wilson was the teacher, who was paid $14 a month to teach 12 scholars. The first frame school was built in 1865 on the site that was later to be the location of the livery stable. In 1876, two acres on the top of a hill were purchased, and this 30-by-40-foot brick school was built.

The students of the 1888–1889 school year pose in front of the school, proudly displaying the globe, textbooks, the school bell, a box, and a poster for a school event. Only two people are identified: principal Hoyt Newcom, next to the poster, and teacher Julia Ellenwood, behind the table. In June 1888, the first graduation was held in the Baptist church for Anne Ellenwood, Sadie M. Smith, Mary S. Holmes, and Hellean Robbins.

By 1914, the town had grown because of the Atlantic, Northern and Southern Railway, and a new, larger, better-equipped school was needed. In 1921, the boys at the school, including Paul Wahlund, Earl Spiker, Harold Embree, Darl Ashbaugh, Edwin Curry, Leland Romig, and Fred Westover installed electric lights. In 1947, the high school was closed. In 1960, it was voted to consolidate with the Griswold Community School. At the end of the 1971 school year, the building was torn down.

In 1936, the school began using Jones Hall as a gymnasium, and in 1942, bought this hall and remodeled it. The school was closed in 1947, and there were only two graduates that year: Mary Bryson and Betty Weston. The last graduate from eighth grade was Violet Miller in 1959. The old gymnasium sat empty until 1949, when Earl Spiker bought it and established a new home for the 71 Garage, which was originally established in 1927.

Work crews are busy laying track across the Nodaway River. The Atlantic, Northern and Southern Railway was completed on December 31, 1910. Its arrival changed life in Grant in many ways.

People gather to watch the track-laying machine at work after it crossed the Nodaway River. The railroad brought so much hope to the residents and boosted the growth of the town. It employed 115 men. It was a shock to the people when news came that the railroad was dead. Every effort was made to keep it going, but it was shut down on January 15, 1915.

On December 29, 1910, the first train came through Grant. It had a passenger car, a coal car, and an engine. There is a banner on the side of the passenger car, and people look out the windows as residents of Grant come see the train. At the time, Grant's population was 250 persons. The town was growing, and in the mid-1920s, the population grew to 800. Later the population settled back to about 350 people.

Here are the depot and water tower along the tracks.

The stockyards were located close to the depot to facilitate shipping of livestock to market for sale. Cattle and hogs were raised in the area.

It was near sundown one day in August 1903, and Frank "Hop" Kenworthy and Bert Sadler were moving a threshing outfit from one farm to another. One mile east of Grant, they began to cross a wooden bridge on a little-used road when it collapsed. The two men were pinned under tons of steel and lumber with scalding water from the boiler burning them. Their screams brought farmers from their fields. Three doctors treated the men, but each lost a leg. Kenworthy was fitted with a peg leg, wearing out more than four of them. He was affectionately called "Hop."

Below the Grant dam, Mrs. Andrew (Blossom) Wahland is in her carriage. She was a schoolteacher for many years in the area. Boys in the background wade in the water, some other men on the bank watch, and a group sits on the wall. The first dam across the river was built in 1854.

Boating became a popular pastime on the Nodaway River. In 1905, the *Nancy Hanks* steams along, carrying a full load of passengers. A boat was launched above the dam for passengers during the Fourth of July celebration and later at the old soldier's reunion. Elmer Smith, the owner, was an admirer of Abraham Lincoln and named the vessel after Nancy Hanks, Lincoln's first love. The boat was loaded to the gunnels with people who each paid 10¢ for a ride. It was in service for about two years.

Grant has had more than its fair share of fires. On October 20, 1915, fire burned down $33,000 worth of property. The buildings destroyed included the Farmer's Savings Bank, Schuler's Hardware Store, Kenworthy's Pool Hall, and Bacon's Produce House. The fire began in the Fleeharty Restaurant. This shot was taken as the hardware store burned fiercely. Afterward, the town council decided it should not be allowed to erect any more buildings of wood.

R. A. Bacon discovered the fire around midnight; it was already out of control. Here his poultry and egg house is about to collapse in the fire. Next door, the bank, built in 1902 is also a total loss. In the background, the hardware store is also ablaze. By November, rebuilding had begun.

In the aftermath of the fire, this is all that remains of the hardware store. As the fire still smolders, men gather to assess the situation. This was taken from the back of the store. There was no fire department to fight the many fires that broke out over the years. The citizens banned together each time to battle the blazes that plagued the town. The first fire equipment was purchased in 1935 and was stored in Spiker's garage under Jarvis's store. Finally in 1954, donations and money from the town made it possible to build a fire station.

After the fire devastated the bank, all that was left intact was the vault. A plank supported by the foundation spans across where the floor had been so that the bankers can get to the vault to open it. Clark K. Givens is first man in line; none of the others are identified.

Looking west from Vetter's store, Adam Adams Sr. drives the buggy with the pinto horse. The Baptist church is in the background. Cars and horses and buggies were all used to travel the dirt streets. In 1917, the idea of electricity was proposed. Streets were lit by lampposts with a square box on top and a kerosene lamp inside. Later power was generated at the mill.

Here is Green Bay Lumber Company in 1911, which provided residents with American fences and gates, cement, blocks, brick, and all kinds of building material. In 1912, it was purchased by the Fullerton Lumber Company, the largest lumberyard in southwest Iowa. In 1920, the lumberyard, the Baptist church, the blacksmith's shop, a carpenter shop, and a few residences burned to the ground.

Seen here is a photograph of the Legion Post No. 445 and the Grant Iowa Post Office, where they also sold groceries and Coca Cola. It was built in 1922. On Saturday nights, Lois Blackburn played the music for the silent films flickering upon the screen.

Paul M. Wahlund built the Wahlund Mechanical Factory in 1948. The 5,000-square-foot floor space was built of concrete and tile and housed facilities for designing, production, advertising, fabrication, packaging, and shipping for the tool- and pattern-manufacturing firm. The shop also did custom work for machinery-supply houses all over the country.

This photograph shows the pump in the intersection at the lower left. Also seen is Vetter's store, with a door to an apartment above. The first town well was dug in the middle of Main Street in Milford in 1858. It had a wooden trough for watering horses and a dipper chained to the pump that all drank from without the fear of germs. By 1914, a concrete platform replaced the wooden one, and a small, galvanized tank replaced the wooden trough.

This postcard view shows a residence scene at the Fox Street corner looking north. The Wahlunds' house is in front.

Here is another postcard with residences depicted. This is the west side of the street in back of the Methodist Episcopal Church. The houses are listed as owned by Workman, Wasmer, Donohue, and Norcross.

The Civil War monument was dedicated in 1909 at the Memorial Day services. Thirty-four men served in that war. The men of Douglas Township have served their country beginning with the Black Hawk War. Thanks to the tireless efforts of Fern Zappe, the records of the cemetery were complied as best as they could be from old records; however, the exact location of the graves can not be determined.

71

This is an aerial view of Grant and the meandering Nodaway River. The *Grant Chief* was the newspaper that covered town events beginning in 1911. Lafe Hill was its first owner-editor. The paper survived until 1921 when W. T. Willey was editor and S. E. Smith and Son were owners. They bought the paper in 1917.

Six

WASHINGTON TOWNSHIP

Sam Moore was the first to settle in Washington Township in either 1850 or 1853 (accounts differ). Isaac Bolt arrived in 1851 after walking from St. Joseph, Missouri. He carried provisions in a bandana and decided to settle when they ran out. He proceeded to acquire 1,000 acres of government land.

Samuel Riggs was allotted $8.43 for locating a road through Montgomery County, and by 1853, a road was established. In 1854, a post office was established at Sciola. It was the first in the county. Chauncey Sager was postmaster, and Riggs carried the mail on horseback once a week. Later a hack was put on the route. Tradition relates that Sciola was a Native American girl's name and was chosen as the settlement's name by the postmaster's daughter Lucinda Sager, who later married John Bolt. In 1857, Sciola consisted of a sawmill and a grocery store built of slabs.

Perry B. "Buckskin" Tracy established the Western Stage Company in 1858 and started a daily hack line through the county along this road. The line did not pay, and it took over Riggs mail route and used a buckboard when there were no passengers. There were not many people in the county at the time, and at first, it was not profitable to utilize the hack, but as the population increased, the hack was kept in use continuously. Sciola was where horses and drivers were changed. At this time, there were no bridges, and rivers were forded. It was not until 1864 that a bridge was contracted for, and it was built in 1866 across the Nodaway River.

The census of businesses in 1860 lists John C. Robb (wagon maker), Charles Beasley (carpenter), Michael Doyer (prairie breaker), Edward Adair (physician and surgeon), Jed Cooney (carpenter), Anna Dolbell (schoolteacher) residing in the J. W. Patterson household, Simon Campbell (stage driver), and Perry Tracy (stage driver and Buckskin's nephew). Both drivers lived in the residence of Isaac Bolt, whose household also included his family, a domestic servant, and two farm laborers.

In 1851, Chief Mahaska was slain on the banks of the Nodaway River. The Sac and Fox Nation had come into the area after being removed from Illinois and began a war with the Iowa Nation. Mahaska and 1,000 of his people were all that was left after an attack by the Sac and Fox nearly wiped them out. One legend says that Mahaska had a trusted friend slay him rather than be taken prisoner by their enemies, and another story relates that his death was as an act of treachery.

About 1857, settlers decided to create a town site in a heavily wooded area at Arlington where there was a mill along the Nodaway River. However, Villisca was to become the flourishing settlement in the Nodaway River valley, not Arlington. This is the Arlington dam that powered the mill. In 1855, J. W. Wallingsford put in a steam sawmill near the Sager's home on the Nodaway River. The county awarded $70 for the building of a bridge on the county road at Wallingsford's steam mill.

Polly "Grandma" Wheeler was born on July 24, 1800, and had the rare distinction of having her life span three centuries. In July 1900, she celebrated her 100th birthday at her son Merritt's home. She is pictured here, weighing 70 pounds. She was the mother of 10 children, and she loved to smoke a clay pipe. She died of the grip on March 13, 1901, at her son Merritt's home.

Some 800 people attended Wheeler's birthday celebration. Until that time, she lived during every presidential administration except that of George Washington. She smoked her clay pipe and enjoyed the attention her birthday brought her. She is seated in the front row surrounded by family and friends.

The Sciola Baptist congregation was organized in January 1869 and built a little frame church in 1871. It was dedicated in June 1872 by Rev. J. C. Otis of Glenwood. By 1904, W. W. Merritt writes in his history, *A History of Montgomery County, Iowa*, that the church had fallen into partial disuse due to a declining membership. The church was moved to the west side of the cemetery in 1970 due to the relocation of Highway 71. By then, it had become the Sciola Community Church and was nondenominational. There are no records for the cemetery.

On January 22, 1866, the Methodist Episcopal congregation was organized. The church was built and named for Rev. John Milton Holmes. It is traditionally believed that he oversaw the construction of the church and that he preached the first sermon delivered in the new building. With a dwindling congregation, the church was sold in March 1928, and the Holmes Chapel was torn down.

The old No. 5 schoolhouse is pictured here around 1871. Most people in this photograph are unidentified, except for Susan Humaston Wheeler, the woman in the center wearing the black dress; Orville Wheeler Damuth, who is behind her in the hat; and L. C. Woster, the teacher. There are two claims for the first school in the township, including one that states it was held in the home of James Robertson with James Rogers as the teacher, and the other that says it was held in Mr. Goble's house with Thomas Stockton teaching about 25 students. The first school was probably built at Arlington.

Students of the Sciola School No. 5 are seated in their classroom in the spring of 1908. From left to right are (first row) Nellie Richie, Lola Murphy, and Golda Sederburg; (second row) unidentified, Lucile Wheeler, and Mabel Richie; (third row) three unidentified, and Donald Wheeler. Also pictured are Albert Richie, Sharon Murphy, Roy Archer, Ernest Sederburg, Raymond Richie, and Austin Murphy.

The Sciola Cornet Band was organized in December 1899. John Mullen (drum major) is seated at the front. From left to right are (first row) Jesse Hinshaw (bass drum), director Sam Moyer (cornet), John Prather (cornet), Burleigh Mayhew (cornet), Lars Larson (cornet), Ben Moyer (trombone), and Albert Sandosky (snare drum); (second row) Henry Butenhoff (tuba), Joe Marvick (French horn), Clay Mayhew (French horn), Clint Powers (French horn), Jess Sickler (French horn), Summer Wheeler (trombone), and John Sandosky (clarinet).

Here is the Atlantic, Northern and Southern Railway depot in Sciola. Grading for the railroad began on October 20, 1919, with Guy Bowers in charge. In September 1912, the platform for the new depot arrived, and by January 1913, it was reported that the depot was nearly complete and that a stove was installed to keep passengers warm while waiting for their train. The new railroad was nicknamed the "Aunt Nora and Sue."

Seven

GARFIELD TOWNSHIP

On September 6, 1870, the county board established a new township, naming it Stanton after secretary of war Edwin M. Stanton. The first elections were held in the town of Hawthorne. The township name was reconsidered, dissolved until January 4, 1871, and then named Walnut. This time, elections were held in a school. It is not known for certain when the name of the township was changed from Walnut to Garfield.

Stephen Glanden was the first settler in the area, arriving around 1851. It was not for another 10 years that there were other settlers arriving. In 1870, Benjamin F. Runnels arrived, settling in Hawthorne. He kept the first post office. The Methodist Episcopal Church and school district No. 1 were established in 1876. Hawthorne was a thriving community and boasted of two elevators, a blacksmith, a lumberyard, a depot, a saloon, two stores, a church, and many residences. Clyde Cessna was born in Hawthorne and spent the first five years of his life there before moving to Wichita, Kansas, and later creating the Cessna Aircraft Company.

The town of Hebron, as it was originally called, was renamed McPherson to honor Judge Smith McPherson. It was because the Chicago, Burlington and Quincy Railroad missed the town of Hawthorne when the track was put down that the town of McPherson came into being where the road crossed the tracks. Homes and businesses were moved in from Hawthorne. The elevator was built by B. F. Runnels in 1874, and the store was built by Carr in 1877. McPherson did not survive long. In 1921, the roof of elevator caught fire, and it burned everything north of the tracks except for the section house and the boxcars in which people were living.

Here is a plat map and a hand-drawn map of Hawthorne indicating the stores and who lived where. They were drawn in 1980 by "Uncle" Charley Vannausdle and Emma Vannausdle. He died shortly after at age 87. The two maps differ a little, but his recollections of the shops and residents gives a look back.

The Hascall family store was one of the best-known landmarks in town and was operated by them from 1900 to 1905, when Ed Anderson and Lew Gilland purchased it. The team at left is driven by Art Vannausdle, and on the right are Ray and Ralph Vannausdle. They operated a butcher shop in the building next to the Hascall store.

80

Pictured are village blacksmith Otto Brodd's house and shop. Brodd is seen here working on a horse held by John Olson. The Brodds were also well known for their amazing rock garden.

The Hawthorne Methodist Church had its origins in the first congregation organized in 1865, which first met in Carr's schoolhouse. When that building was moved, members began holding services in a schoolhouse on Walnut Creek. People gave money, and there was a strawberry festival that netted $27.40 for the church fund. The Methodist church was built and dedicated in 1889, with 400 in attendance. In 1990, it celebrated 125 years.

Benjamin Franklin Runnels is pictured with his son Walter. Runnels was a teacher and sold books on the history of the United States and *Universal History of the World*. He came to Montgomery County in the 1850s, liked it, and saved enough money to buy land at $1.25 an acre in Montgomery and Page Counties. In 1858, he brought his wife and three sons to their new home. With the advent of the railroad, Runnels was named postmaster of Hawthorne.

For 10 years, Runnels had limestone quarried near Stennett and Macadonia delivered by the wagonload until he had enough to build a fine, French mansard–style Victorian home. It was completed in 1882. In 1883, his daughter was married in the home to a Swedish immigrant working for her father. They met when she was 10 and he was 15. The home was known as the Pines, Fairview Place, and the Hawthorne house. Runnels died in his home in 1914.

In 1996, the house sat, awaiting further destruction. The slate roof was done in moss greens, with blue and red forming a diamond pattern. Stone inscriptions were carved around the two-story bay windows. The first floor had three large rooms with high ceilings and solid walnut floors, doors, and knobs. The ornate woodwork had inlays of a lighter wood to compliment the walnut and gold trim. The front doors had frosted glass panels of a pheasant and bouquet of flowers. Shutters featured glass panels instead of louvers.

Over the years, the house was ravaged by vandals and thieves. There once was a large porch. The house was placed on the historic register in 1979 with the hopes to restore it, but nothing was done. Its limestone shell, which formerly rested on a ridge overlooking Hawthorne five miles west of Red Oak, was burned and demolished in the spring of 1997. At one time, it was one of the finest houses in the county.

Early on a Monday morning at the end of May in 1921, a fire began in the elevator. It was suspected that it was sparked from a passing locomotive. By 1:00 a.m., Mrs. Bowman was awakened by the furious blaze, and only a few pieces of her furniture were saved. The entire town of McPherson was reduced to ashes except for the depot. The buildings were considered historic, as many had been moved in from Hawthorne.

The depot and the section boss's house were moved from Hawthorne to the south side of the tracks. Two other houses were moved from Hawthorne, as well as the elevators, the two-story Lodge Hall, a scale, and coal sheds. The first floor was a garage and storage, and sometimes the second floor used when Hawthorne ladies served oyster suppers. The Peaks ran the grocery.

Eight
West Township

West Township was created on July 3, 1854, and in August, an election was held at the log cabin home of James Shanks. In 1854, Doran T. Hunt and Stephen Glandon came to what would become Climax. Jonathan Wax arrived in 1855. More families arrived around the same time, including those with the names Myers, Gibbuth, Lackey, Montgomery, and Carr. Frank Norris came to Climax in 1881 with his parents and settled on a farm. Although the Native Americans were given lands in other territories, they still returned to hunt for a few years after settlement had begun in the area.

The first school in the county was held in a log cabin in 1857. Sophronia Dean, who later became Sophronia Shanks, was their teacher. Among the first scholars were Eliza Montgomery, William Hunt, Alf Lackey, Tom Montgomery, Tom Glandon, Andy Glandon, and William Watt. Later a schoolhouse was built on the west side of the road on the south bank of the creek. It was also used as a church until 1874, when a church was built.

Houses were built of logs using native timber. Walnut, red oak, and cottonwood grew in thick groves along the river. To finance the purchase of some land, one settler trapped raccoons then took their hides to Council Bluffs and sold them. He received enough money to purchase 40 acres of land; the going rate was $1.25 an acre. When the railroad came, the price went up to $20 an acre.

The Chicago, Burlington and Quincy Railroad came to Red Oak 1869. The Nebraska City branch was built in 1870, and the Wabash Railroad was built in 1874. In 1881, an iron bridge spanned Walnut Creek. It was the only bridge across that creek.

Carr's Point was the halfway house along the Western Stage Line heading west out of Red Oak to where the trail crossed the Missouri River on a ferry at Nebraska City. Pictured from left to right in this 1886 photograph are George Wookey, Mr. and Mrs. A. P. Wookey (seated), Henry Wookey, Ed Wookey, and Ellen Fisher (seated) with a niece from England standing at her side.

At Carr's Point, freighters and travelers stopped for the night in the days of the stagecoach lines. The Wookey family lived in the old place for many years until a new house was built, which was moved a short distance away but fell into disrepair. In June 1950, Henry Wookey and a crew dismantled the old house.

Built by Glover and Oxley, the old Climax mill was run by a waterwheel and operated by W. A. Grover. Soon stores were built as a town emerged. A sawmill was built on Walnut Creek in 1866, and the gristmill for grinding grain was erected in 1875 by Mr. and Mrs. B. R. Bridge. In 1875, the mill was extremely busy and ran more days of the year than any other in the county.

There was always a threat of spring floods and high water washing out the dam because of the Walnut River. The first bridge to span its waters was built by Benjamin Franklin Runnels in 1859. In 1908, the dam at the Climax North Mill was washed away by spring flooding.

The Climax General Store served residents for many years until it burned in 1936. Climax once had a blacksmith shop, a general store, a telephone office, and a number of homes, but by 1953, all that remained was one house and the church.

The Methodist Episcopal congregation in Climax was first organized in Carr's schoolhouse around January 1865 and burned in 1922. The Climax Methodist Protestant congregation was organized in 1856, and the church was built in 1875. Salem Church was organized in 1888 by Evangelicals from the eastern part of the state.

This photograph was taken around 1900 of the Bishop family home. Pictured from left to right are Mrs. George Bishop, a son and his colt, two other Bishop children with a horse, and Walter and Dewy Bishop.

In 1856, Sophronia Dean came from Potawatomi County, where she was living with her parents, to teach in the first school in the area. By 1880, there were nine ungraded schools in the township with 18 teachers to educate the 314 pupils. In the 1920s, the schools planned to consolidate and build a central school building, but that did not last very long.

Climax Telephone Co.

Line No. 2

Phone No. 1—Emmett Cahill
Phone No. 4—Bud Allen
Phone No. 5—Will Bootenhoff
Phone No. 6—C. A. Allen
Phone No. 7—Alfred Griffin
Phone No. 8—Sherman Allen
Phone No. 9—E. A. Jenks
Phone No. 10—Will Liston
Phone No. 12—J. E. Gibson
Phone No. 13—Walter Kellenbarger
Phone No. 14—Jim Ungry
Phone No. 18—Arthur Allen
Phone No. 28—Will Cooper

Line No. 3

Phone No. 1—C. A. Hunt
Phone No. 4—Mrs. Nora McPherson
Phone No. 5—Lon Hunt
Phone No. 6—Walter Graham
Phone No. 7—Peter Doyle
Phone No. 8—Evert Hichlos
Phone No. 10—Joe Gutchenritter
Phone No. 11—Henry Wax
Phone No. 12—John Perkins
Phone No. 15—Paul Pritchard
Phone No. 20—Pat Feeley
Phone No. 23—M. Delehant

Line No. 4

4F1—Elmer Hendrickson
4F4—R. H. Smith
4F5—C. J. Hendrickson
4F6—F. C. Withrow
4F7—Elmer Carlson
4F8—P. W. Clawson
4F9—Sam Mitchell
4F11—W. E. Reasoner
4F12—Kate Higgins
4F13—J. W. Klepinger
4F14—W. A. Jackson
4F15—G. W. Harvey
4F16—Will's Cottrell
4F19—D. C. Echard
4F20—Oliver Howard
4F21—J. M. Harville
4F22—Ira J. Black
4F23—Vant Abney
4F24—W. P. Long
4F25—J. L. Holman
4F27—G. W. Glandon
4F29—Gorarson Bros.

Line No. 6

Phone No. 1—Mrs. Lizzie Hascall
Phone No. 4—J. W. Hamilton
Phone No. 16—(Not in use)
Phone No. 7—George Eisel
Phone No. 11—C. E. Eastwood

Line No. 7

Phone No. 1—Wickman Bros.
Phone No. 5—N. J. Woodin
Phone No. 6—Will Resh
Phone No. 10—R. E. Berlin
Phone No. 11—Ed Woodin
Phone No. 12—Albert Fallers
Phone No. 13—Homer Hush
Phone No. 14—C. E. Klepinger
Phone No. 15—Toss Hush
Phone No. 18—B. F. Allender
Phone No. 19—Frank Johnson
Phone No. 20—Ray VanAusdale
Phone No. 24—B. R. Bridge
Phone No. 25—Rounds Bros.
Phone No. 27—Forest Pickerel
Phone No. 28—B. R. Woodin
Phone No. 29—O. L. Chabot

Line No. 11

Phone No. 1—Mrs. A. W. Parker
Phone No. 4—John Malmberg
Phone No. 5—Ed Rerneck
Phone No. 6—S. P. Johnson
Phone No. 7—Wm. Knox
Phone No. 8—J. W. Hipsley
Phone No. 9—Frank Carlson
Phone No. 10—Mrs. F. M. Jones
Phone No. 11—Luther Johnson
Phone No. 12—Mr. Haley
Phone No. 13—Gust A. Anderson
Phone No. 14—Eric Lingren
Phone No. 15—W. C. Flynn, Sr.
Phone No. 16—Fisk Flynn
Phone No. 18—Andrew Johnson
Phone No. 19—Ray Alexander
Phone No. 20—Joe Johnson
Phone No. 21—Jim Fryear
Phone No. 22—Frank Pritchard
Phone No. 23—
Phone No. 24—King Fulton
Phone No. 25—J. P. Hendrickson
Phone No. 28—Charley Holmes

Line No. 12

Phone No. 1—Floyd McMullen
Phone No. 4—Harry Kellenbarger
Phone No. 5—A. S. Horeyman
Phone No. 7—Wilbur Adams
Phone No. 12—J. L. Lindzay
Phone No. 15—Ira Ballain
Phone No. 16—Frank McLain
Phone No. 20—Frank Cardiff
Phone No. 21—Carl Lundeen
Phone No. 22—Glenn Whipple
Phone No. 23—Alfred Lundeen
Phone No. 24—George Clites
Phone No. 25—Clarence Bishop
Phone No. 28—Alfred Cooper
Phone No. 29—George Bass

Line No. 15

15F1—Charles Anderson
15F2—Jas. Roach
15F3—G. E. Carlson
15F4—Nathan Tucker
15F6—Jake Wildman
15F7—Bert Kimber
15F8—Mrs. Mollie Dixon
15F9—J. P. Higgins
15F10—J. A. McPherson
15F11—Charlie VanAusdale
15F12—C. E. Henderson
15F14—Carl Fransenn
15F15—D. M. Alltaffer
15F16—McGreer Bros. Office
15F17—Ira Straight
15F18—Henry Lenhart
15F19—J. M. McGreer
15F20—Henry Wright
15F21—O. E. Davis
15F22—C. E. Cozad
15F23—G. R. Pim
15F24—Russell Cilmore
15F25—Roy Martin
15F26—Frank Tucker
15F27—Cliff Emil
15F28—E. C. Roach

Line No. 17

Phone No. 1—J. P. Hilgerson
Phone No. 4—Claus Abraham
Phone No. 5—Frank Levine
Phone No. 7—Herbert Hagg
Phone No. 8—Wm. Freeman
Phone No. 9—J. M. Hilgerson
Phone No. 12—Aug. Johnson
Phone No. 13—Dave Anderson
Phone No. 15—Ludwig Bengston
Phone No. 16—J. E. Carlson
Phone No. 20—Victor Bengston
Phone No. 21—J. M. Liljedahl
Phone No. 22—Lenus Hagglund
Phone No. 23—C. A. Youngren

Line No. 24

24F3—Ed Burton
24F4—Nathan Tucker
24F6—Bud Stafford
24F7—Robert Turney
24F8—Lud Pearson
24F9—Jack Higgins
24F11—Walter Glandon
24F12—Frank Higgins
24F16—McGreer Bros. Office, Coburg
24F18—B. F. Allender
24F19—J. M. McGreer
24F20—W. Clites
24F21—Jack Smith
24F24—Pearl Roberts
24F25—George Bruce
24F26—Frank Tucker
24F27—Keister & Collins, Coburg
24F29—Tom Beeson

EMERSON CHRONICLE PRINT

This is the Climax phone list. At the time, a phone was a large, wooden box mounted on the wall with a storage box to hold the dry-cell batteries. It had a hand crank on the side. There were usually about 6 to 12 customers on a line, and it was easy and common to listen in on someone else's conversation. To get the operator, several revolutions of the crank handle were needed. The cranks gave the number. For example, the number 40 would be four short turns of the crank and one long one. Early on, the phone lines were strung down fences, on poles, wobbly posts, and even dead trees.

Nine

Grant Township

About 1852, Mormons made surveys, setting stakes for a town in what became Grant Township. Western Iowa was where they had planned to found their apostolic city at Kanesville, but there was a separation over the issue of polygamy. The Brigamites, polygamists, went on to Utah, and the Josephites remained in Potawatomi and Mills Counties. No settlement was founded in what was to become Montgomery County; however, the stakes set for the Mormon town were still in place as late as 1857, and Mormon Creek was named for them. On January 8, 1868, the township was formed out of Red Oak Township and named Grant. J. H. Brown as the first member to the county board, taking his seat in 1869.

The first parish was the Good Hope Methodist Church, organized in October 1859 by Rev. J. M. Young. Coburg Methodist Episcopal Church was organized on February 19, 1880, and built in August at a cost of $1,675. Binns Chapel, a Methodist congregation, was built in 1880 at Binns Grove in Page County and later moved to Grant Township. It was later dismantled and used to build the Methodist parsonage in Stanton. Hewett Cemetery was given by Joseph Meredith Hewett, an early justice of the peace and city supervisor.

Schools served as churches until the churches were built. William Cozad recalled that the first schoolhouse was moved from Red Oak in 1863. Mary Etta Barker taught school in Robert Davis's log house for a salary of $13 a month. At one time, there were nine ungraded schools, but they were consolidated at Coburg and Mount Pleasant, and buildings were put to other uses.

On June 7, 1875, the county board of supervisors passed a resolution to purchase land and establish a poor farm at a cost not to exceed $5,000. Land was purchased from Miriam and H. C. French and Andrew Binns. The building was completed and opened in 1876. In 1880, a one-story building was added expressly for the incurably insane, and in 1899, it was enlarged.

In 1881, Coburg was the only station besides Red Oak on the Nebraska City branch of the Burlington and Missouri River Railroad (acquired by the Chicago, Burlington and Quincy Railroad). It opened in July 1870. Coburg was an important shipping hub. It was platted by Justice Clark, D. N. Smith, and the Burlington and Missouri River Railroad Company. The original plat was larger in anticipation of settlement, but it was reduced.

This is the Gilmore store. Coburg was one of Montgomery County's smallest incorporated towns. Founded in 1868 and incorporated in 1870, it was named after Coburg in Germany. Original names on the incorporation papers included D. N. Smith, Josiah Smith, Justice Clark, and Elizabeth Clark. Mr. Newcomer built the first store there.

Amil Nelson is in his blacksmith shop about 1912. Coburg had a blacksmith shop, a seed business, a lumberyard, grocery stores, a post office, and a bank, as well as a town band. The first postmaster was E. Kretchmer, appointed in 1871.

Workers cut and haul wood with their portable sawmill on Walt and Earl Jackson's farm near Coburg around 1900.

Pictured is a girls' sewing class at the Coburg school. From left to right around the table are two unidentified girls, Viola Bruce, Gertrude Davis, unidentified, Blanche Sammer, teacher Miss Calline of Essex, Inez Axelson, Helen Drollinger, Leora Liljedahl, Hazel Woodin, Ethel Wyckman, and Irene Dado.

Here is the high school in 1927 with the fleet of busses to pick up and deliver the students in the township.

A boys' manual training class is shown here. From left to right are Paul Carlson, Farris Cottrell, Ray Woodin (front), Fred Woodin, unidentified, Alan Mainquist, Gage Buxton, Paul Peterson, Russel Harville, and unidentified.

Boys are seen at basketball practice in the high school gym. From left to right are Russel Harville, Ferris Corrtell, unidentified, Roy Woodin, Paul Callson, Paul Peterson, Fred Woodin, Allen Mainquist, unidentified, Gage Buxton, and Moe ?.

95

Four generations are pictured at the post office on August 24, 1954. Postmistress Blanche Conkel (standing, left), assistant postmistress Lois McCoy (standing, right), and Lois's child, held by Lois's grandmother, are seen. The post office doubled as a nursery. The frame structure was once a barbershop, but it was converted to the post office and moved to Conkel's front yard. In 1951, receipts were $562 and postmaster Conkel's salary was $1,588.48. Mail deliveries arrived from Red Oak at 6:30 a.m. and 1:40 p.m.

Between 1940 and 1945, sheriff John Conkel discovered this still. The men stand amid part of a $5,000 still that they discovered five miles south of Red Oak on a Friday night. Capacity was estimated at 500 gallons daily. Bootleggers fixed up their cars so they could outrun the law and protect their product. They began competing against one another, and stock car racing was born.

Ten
Scott Township

As Frankfort was breathing its last breath, a new city began to emerge along the main line of the railroad. Around 1869 in Burlington, Rev. Bengt Magnus Halland happened to overhear a conversation of some railroad officials, he asked them a few questions and was soon able to realize a dream he had of founding a settlement for his fellow countrymen from Sweden.

Scott Township was organized in 1870, and the original plat was filed on October 24, 1870. Beginning in April 1870, he advertised for nondrinking, God-fearing Swedes to come create a little bit of Sweden in America. Many came via Illinois. Land sold for $6 to $11 an acre. Anders Ossian, his wife, and their children are believed to be the first to arrive on April 2, 1870. The first lot was purchased by Malcolm Holm.

Halland wanted to name his settlement Hemlandet for the leading city in his province in Sweden; however, railroad officials had trouble pronouncing it and opted to call the new city Stanton. Stanton was incorporated in 1882, and E. E. Mercer was the first mayor.

Stanton's most famous citizen was a young woman who became an actress. Virginia Rickets was born in Stanton in 1920, but Virginia Christine was her professional name. She appeared in 150 movies and 300 television shows and did voices for cartoons, but she is best remembered for playing Mrs. Olson for the Folgers coffee company. She was their spokesperson from 1963 to 1986. The water tower in Stanton was painted in bright colors to look like a Swedish coffee pot in her honor, and the second water tower is now a teapot.

Rev. Bengt Magnus Halland, who had a vision of a settlement for Swedish immigrants, came to Stanton with his wife and seven children. He was the driving force in making Stanton into the city it is today.

This is the oldest known photograph of Stanton, taken around 1888. In 1884, on Stanton's main street, Broad Avenue, though it was rarely called that, there were three general merchandise and grocery stores, a lumberyard, a first-class restaurant, two hardware stores, a newspaper office, a furniture store, a bank, a drugstore, a church, a school, a shoe store, a hotel, and a feed store.

Stanton's first rural mail carrier Louis T. Larson and his horse and buggy are in front of the City Hotel on Broad Avenue with two men. The first post office was in Peterson at Hogwell's store at the corner of Thorn Avenue and Broad Street. Mail was dispatched by the store owners. Later the post office was moved to A. F. Newquist's Refectory restaurant. It was housed in many places before a post office was built in 1963.

Here is a street scene from a postcard of Stanton around 1912. Stanton was known as the Swedish capital of Iowa and as the "little white city," because most of the houses were painted white.

Rev. Bengt Magnus Halland believed that there should be a home for Swedish children bereft of their parents. The Swedish Evangelical Lutheran Orphan's Home of Iowa was begun in 1870 and incorporated on August 6, 1872.

A new brick dorm and superintendent's cottage were built in 1917. Hundreds of children were cared for by the Lutheran orphan's home until it closed in 1938. Ironically the Mamrelund church was struck by lightning a month before the last orphan was sent away before the orphanage closed. Some felt this was God voicing an opinion. The abandoned buildings sat empty for many years before they were torn down.

This school was called Old Main and was built in 1885. Stanton public schools were organized in 1878, and commencement was held in the Lutheran church. An elementary school was built in 1952, a kindergarten was completed in 1957, and a junior and senior high was constructed in 1970. The Old Main was preserved and is currently the Swedish Cultural center and museum.

The Mission Covenant Church was founded after there was some disagreement in the interpretation of scripture. It was founded on April 3, 1879, in the home of John Oak. In 1880, a church was built, and it was dedicated that September.

Stanton Mamrelund Lutheran Church was organized in 1870. Mamrelund was the name chosen from Genesis 13:18. In January 1871, Rev. Bengt Magnus accepted the call to serve as pastor. The congregation outgrew its building quickly. In this photograph taken around 1884, the two churches stand next to each other. The church was referred to as the big, white church.

Early on Sunday morning, August 28, 1938, the church was hit by lightning, and the fire completely destroyed the building. Even the cross on the steeple was reduced to charred timbers.

Little was left but the stone foundation. Within the cornerstone was a time capsule. This was found and opened. Inside were photographs, letters, copies of the *Stanton Call*, and many publications in Swedish. A few weeks later in the school gymnasium, the decision was made to rebuild.

New Mamrelund Lutheran Church was dedicated on May 26, 1940. The church was full to overflowing. A new big, white church graced the "little white city."

This *Stanton Viking* newspaper reporter is hard at work in 1951. The first newspaper was the *Stanton Call*, established in 1882 by Kennedy and Thurman. It continued until October 28, 1937. Vernon Hoyt started the *Stanton Zephyr* on December 17, 1937, publishing until 1950. In 1951, Bernard Wickstrom started the *Stanton Viking*, "the Voice of the Little White City." It closed in the 1960s.

The first organized baseball game was in 1901. A few years later, Stanton had a professional team. In 1936, they represented Iowa in the national tournament in Kentucky. Stanton has been holding baseball day since 1941. In 1947, the Stanton Vikings was one of the top baseball clubs in southwest Iowa. Pictured from left to right are (first row) Darry Gleason, Orville "Shorty" Nelson, Mickey Owen, Eldon Jones, manager Don Schenck, Ken Schenck, Darrell Nuckolls, and Glen Josephson; (second row) Carl Mattson, Sherman Peterson, Virgil Lundgren, Dale Nuckolls, Donald Peterson, Marvin Peterson, Clayton Johnson, and Lu Olson. Bobby Thompson, the batboy, is in front. Owen, a former Brooklyn Dodger, was not a regular member of the team. Carl Mattson, not in uniform due to injuries, was the regular catcher.

Eleven

East Township

The first settlement in the county was the town of Rossville, laid out by Hiram Harlow in 1855. There are no records of where it was located, and like so many early settlements, it never came to be. Other settlements were named the Valley, Hungry Hollow, and the Ridge, but these soon became obsolete.

In June 1859, a group of people from Highland City, Ohio, arrived just south of present-day Villisca and unhitched their wagons and horses in the areas they called Ross Grove and the Forks. George West built a log cabin on the land that was to become the city of Villisca. The original name of the township was Jackson, but it was later changed to East Township. Today Villisca is the largest city in East Township, situated just above the confluence of the Nodaway River branches.

They boasted of being healthier than other cities, for the land sloped gently draining off water into the rivers. "Malaria is unknown," boasted A. B. Shaw in 1889. "In the center is a public park of about two acres surrounded with a neat substantial fence, planted with blue grass shaded well by native trees planted on Arbor Day of 1876, a music pavilion in the center."

Villisca could boast of a famous actress having her roots in the city. Shirley Temple's grandparents were from there.

Villisca was the junction of the Brownsville and Nodaway Valley Rail Road and the main line of the Chicago, Burlington and Quincy Railroad, 430 miles from Chicago. Thanks to the trains, at one time, Villisca was the largest city in the county. It is known as a pork producer with many pig farms in the area.

The Dunn family settled early on, and their cabin was built before 1857. The Dunns also built a school in 1857, which was used until 1876 when another was built because the first was too small to accommodate the students. The new school was called Highland.

The Lunch Counter restaurant served meals at all hours. A person could get their meals, lodging, hot and cold drinks, cigars, and tobacco. The Lunch Counter was owned by the Marsh family and was located at the west end of the street near the depot.

This is the Villisca Opera House. The hand-written note says, "Dear Mabel—delighted with town. Rented lovely house with six rooms, lights, city water, close in for eight dollars. Come see me, May." The opera house was enlarged when the back of the Baptist church was added on. Most of the civic functions were held in the opera house.

Villisca was at one time the largest city in the county. When the railroad stopped passenger service, the population began to decline, but it was not the only reason, as people began to move to larger cities, condemning the rural ones.

Before there was a central banking system, greenbacks were minted locally. This was from the Villisca National Bank.

Villisca National Bank was one of two banks in Villisca with a combined capital of $180,000 and deposits of $500,000.

108

First National Bank was erected in 1882. Dr. N. M. McNaughton was its vice president. The Citizens Bank was a private institution. Amos P. West was its president.

Here is Dr. N. M. McNaughton's house; he is in the buggy. He was born in Caledonia, New York, on April 1, 1849. He graduated from Buffalo Medical University on February 22, 1868, came west, and settled in the Forks in 1868. He built several homes and owned 1,000 acres of prime farmland. In 1890, along with Dr. D. W. Jackson, he built the Jackson Block on Third Avenue, and then in early 1900, he began to build the McNaughton building. He represented the progressive spirit of the city. On June 23, 1912, McNaughton died. He was Villisca's wealthiest citizen.

The trains were a great influence on a city and its survival. This is the Atlantic, Northern and Southern Railway depot in Villisca. After passenger service was discontinued, the population of Villisca began to decline.

The Villisca depot was on the main rail line through the county, and it was a railroad hub. The Chicago, Burlington and Quincy Railroad went from Denver to Chicago, with a south branch to Kansas City and St. Joe, Missouri. The depot sat unused for many years, and when it was determined to be too costly to save it, it was torn down.

Here is a bird's-eye view of Villisca, showing the old Burlington depot and Hotel Fisher in 1911. Maude Stump operated the Hotel Fisher. It had electric lights, was heated with a furnace, and offered the best table service and excellent rooms.

The Hotel Ingman was built around 1880 and was originally called the Western House. J. T. Ingman purchased the Western House after fire damaged it in 1900. He remodeled and reopened it as the Hotel Ingman. It burned down on April 24, 1956, and three men lost their lives. It was later called the Elms Hotel, but it burned down in 1956.

Frank P. Tyler is seen cutting ice on Crystal Lake. He came to the area in 1877 in pursuit of the woman he loved, Flora Julia Pasco. He married her in 1878 and began to build a successful business empire. Some of his endeavors included Tyler Ice and Coal, selling the first gasoline and kerosene in the area for Standard Oil, pumping water for the city, making concrete bridges for the county, selling cream, and developing Tyler's Ice Cream—Pure as the Heart of Childhood. He also had a bottling company for soft drinks and even built an airport east of Villisca.

In 1915, Tyler bought a bottling company to sell its flavors and soda water. In the safe was a contract to sell Coca-Cola. At first, it was not as popular as the other flavors, and when the company delivered a mixed tray of sodas, it always added in some of the Coca-Cola bottles. Soon it became worth its weight in gold. Jim Tyler is pictured here with a Coca-Cola stand on wheels about 1930.

Bathing Pool, Tyler's Lake, Villisca, Iowa

Here are Crystal Lake and Tyler Park. Crystal Lake was formed by sinking two wells and was used for cutting ice in winter and for swimming and boating in the summer. A beach, bathing houses, and a toboggan run were added later. Every Wednesday afternoon, ladies had exclusive rights to the toboggan ride. The *Princess Irene* was a launch used for rides on the lake. It was 10¢ a ride.

After World War II, the honor roll of service men on active duty was painted on the west side of the Andrews clothing store in the southwest corner of city square. As the war years passed, more names were added. The advertising man for Tyler Brothers paints names on the community honor roll on a warm day in November, as Mildred Hollingsworth watches.

113

The first high school was built in 1888 for $10,000. It had five teachers, a superintendent, and 130 students. The Lincoln building had 425 students, 10 teachers, and a music teacher who served both buildings along with the superintendent. In the 1970s, the Lincoln building was no longer in use, and in 1976, it was decided to sell it.

Villisca High School was designed by Lloyd D. Willis of Omaha, Nebraska. Hundreds of students passed through these halls and were saddened when the school was razed.

In 1885, Elder Forrester came to Villisca and held a tent meeting at the fairgrounds. Soon after, the Christian church was organized. A small church was built at Fifth Avenue and Third Street. The church was closed a while later but reorganized around 1900. Between 1890 and 1924, the church was raised and foundation blocks were laid in order to put in a basement. In 1958, the school bought the land, and the church was moved to a new location.

Cottage Prayer Meetings were held in people's homes before churches were built or organized. In the fall of 1870, a Cottage Prayer Meeting was the early origins of the first Presbyterian church in Villisca. Their numbers were small in the beginning, with four members covenanting together. Soon membership grew, and they were able to build a church in 1875.

The First Baptist Church was organized in May 1869, and a frame building was erected the following year. About 1906, the building was sold, moved, and used as an opera house. Around this time, the new church was built. In the early 1950s, the church disbanded, and the building was torn down about 1957.

The first Methodist church services were held in 1865, and the church was officially organized in 1866. The first church was built in 1869 at Fifth Street and Fifth Avenue. A new church was built and dedicated in 1896. On November 6, 1938, while Sunday school classes were in session, the church caught fire and burned down. By May 1940, the new church was completed and was debt free by April 1944.

Here is a newspaper clipping about the June 10, 1912, murders that shook Villisca to its foundations, turning people against one another as they took sides about who could have committed this horrible crime. Suspicion fell on one resident, Frank F. Jones. Tensions were high, and people were looking over their shoulders wondering if it would happen again. The murders were never solved.

Six Children Slain June June 9, 1912

Katherine Moore | Herman Moore | Boyd and Paul Moore | Ina Stillinger | Lena Stillinger

Pictured are Mr. and Mrs. Hamilton about 1900. She was considered to be a great fortune-teller. J. Dick Knapp wrote this on the back of the photograph: "She was threatened by Villisca murders scared her from telling Fortunes 1912 murder 8 people killed, I new them all." Her visions of the murders fueled the fires of gossip and unrest in the city. She related that the murderer was a "local man with a beard," implicating Jones. He swore his innocence. Later it was discovered that other similar murders were committed along other stops on the rail line. This was probably the act of a serial killer, not a Villisca resident.

AXMAN PHOTOGRAPHED FROM EYE OF VICTIM

Stout, Broad-Shouldered Man Slew Family at Villisca, Picture Shows; Wore Both Apron and Mask.

Council Bluffs, Ia., Aug. 24.— Detectives at Villisca, near here, working to solve the recent murder of eight persons in that city, have succeeded in getting a photograph of the murderer from the retina of the eye of the Stillinger girl, one of the victims slain with an ax.

The photograph, clearly developed, shows a man of stout build and of extraordinary width between the shoulders. This is the only freakish part of the photograph, caused, it is believed, by the convex surface of the retina. The murderer, according to the photograph, wore an apron and a mask, the former evidently to prevent his clothes being spattered with blood. The photograph, which shows portions of the face clearly, is the only clew to the eight murders.

A sensational article about the 1912 murders was printed in the *Council Bluffs Nonpareil* about a photograph taken from an eyeball lens. Newspapers from all over the county converged on Villisca, attempting to capture every event. The funeral was in the park, and 5,000 people hoped to catch a glimpse of the floral-bedecked coffins as they came from the temporary morgue. It was one of the longest funeral processions ever seen in southern Iowa.

This was the bill to Montgomery County for the bloodhounds used during the murder investigation. Elmer Noffsinger and his famous bloodhounds from Beatrice, Nebraska, were called in. The dogs jumped off the porch of the J. B. Moore house hot on the scent of the murderer; they were led to the river. Three different times, the dogs followed the same route through town to the river where they lost the trail; giving rise to a theory that the murderer escaped in a boat.

118

Twelve

RED OAK TOWNSHIP

Pleasant Jones squatted on some land in 1852, and in 1857, Daniel Remick purchased it from him, hoping that the rumors he heard were true about the advent of the railroad. On March 11, 1854, James Shank filed the first recorded claim.

In 1853, Col. Alfred Hebard did a survey for a railroad route from Burlington to where the Missouri and Platt Rivers merged. Red Oak was already on the only east–west stage route that passed through the area.

In 1855, a post office was established at Oro a few miles north of Red Oak. Joseph Zuber was the postmaster. His wife, Mary Jane Wiley Zuber, is credited with having named the area for the abundance of beautiful Red Oaks growing along the creek.

In 1857, land was pledged for a town site. That same year, Joseph Zuber built the first house, and it served as a hotel called Red Oak House. In 1858, Charles H. Lane opened the first store for business to serve the four houses of Red Oak Junction. They built the town on the hopes and dreams of the future where the rivers met, and that soon roads and rail lines would meet as well. The dream of the railroad was put on hold as the Civil War spanned five Aprils in time.

For years, there was a great rivalry between Red Oak Junction and Frankfort. Red Oak had hopes to become the county seat, especially with the promise of the railroad that would come through Red Oak and bypass Frankfort. It was put to a vote, after some disagreement, and it was ordered that the county seat be removed to Red Oak Junction. The records were to be moved by June 1865 and the courthouse by January 1866.

On March 21, 1869, Webster Eaton put out the first copy of the *Montgomery County Express*, and within a year, he changed it to the *Red Oak Express*. He wrote, "Red Oak Junction can hardly fail to become an important point, especially if she is so fortunate to get a Rail Road, of which there is a strong possibility."

This is an etching done from a work by artist Thomas Moran of the west side of the square in Red Oak. From left to right are the First National Bank; Lane's Bazaar; Powers Dry Goods; the alley; Red Oak Investments; W. H. Evans Jewelry, Pianos and Wallpaper; Schuttler Wagons, a division of Lane Implements that carried a line of fine carriages, plows, and pumps; Everett White's music store; Vanalstine's photograph gallery (upstairs); and William Koehler' grocery store, which also carried crockery, glassware, and lamps.

Another etching depicts the north side of the square. Seen from left to right are George W. Johnston hardware store, Malhberg and Cassner groceries, the Independent Order of Odd Fellows hall (upstairs), Tracy and Swisher dry goods, and within the Red Oak National Bank were Oliver P. Worsely Insurance, the board of trade, and Bromley and Hall bakery. Around the side are the entrances for H. C. Houghton and the Red Oak Express printing offices.

This etching depicts the east side of the square. From left to right are a glove factory with gents' furnishings on the second floor; Baldwin Taylor and Company, offering drugs and medicines; the alley; the horse-drawn trolley is in service; and the Rynearson Opera House Block, with offices for the *Independent* on the first floor, Dan Gunn hats, C. H. Boeclert and Company books and wallpaper, and a dry goods shop. M. E. Fisher, the grocer, also supplied teas, coffee, fruits, and flour.

Here is an old view of the town square looking northwest from the roof of a building. There is a picket fence around the square to keep the horses and cattle off the grass. It is a chilly day, and the horses are blanketed.

121

In 1890, the Osborne Murphy Company commissioned a woodcut of the new courthouse. The artwork was more expensive than planned, so it was used on a wall calendar with advertisements to help defray the cost. It was the beginning of the art calendar industry.

In 1887, Hamilton White built a sanitarium hotel utilizing the mineral springs for the spa. By 1900 it was failing. In 1903, Dr. Francis Powell, superintendent of the Glenwood Institute for the Feeble Minded, bought it and planned to open his own school. He died shortly after but his work was carried on by his widow and his daughter, Dr. Velura Powell. They maintained the school unit the 1940s when it was sold to Riley Nelson. It was finally closed in 1978, and while being converted into a bar burned to the ground.

The courthouse was built in 1890, but Red Oak has been the seat of county government since the 1860s. Once lightning struck the tower, but thanks to some fast work, it was not badly damaged.

This is a rare photograph of the old Houghton Bank before the facade was altered. Mr. Houghton stands on the steps. Diamonds, watches, and clocks were sold next door, and an unidentified man is in front by the door of the jewelry store.

This building houses Doctor the Clothier, a druggist, and a dental office upstairs. It is suspected that this building was on the south side of the square and was destroyed by fire in 1902. Few records of the south side of the square exist from before that fire.

The first jail in the county was built in 1875 and was later converted into a boardinghouse when the new one (pictured) was built in 1900. The jail was in the rear and a residence was in the front. This jail served for over 100 years before there was discussion on replacing it.

Lt. Darwin R. Merritt, assistant engineer on the battleship *Maine*, perished in the harbor of Havana, Cuba, just before the beginning of the Spanish American War in 1898. Two officers and 251 crewmen on the *Maine* lost their lives in the explosion, burning, and sinking of their ship. Many houses had a picture of the battleship etched into the glass panels in doors as a remembrance.

Red Oak High School students and teachers pictured here. Identified are Edna Richardson Palmer, Sarah Palmer, Abbie Chicker, Minnie D., Blanche Miller, M. Gregg, M. Hurlbert, Mina Hughes, Lizzie Kearwille Moore, Mary Mauker, teacher Mary Lambeil, Professor Kauffman, Maude Williams, Rena Manker Harding, Inez Judd, Della McCulloch, Kali Kelly Schwin, Addie Clark Hayes, Nell Bishop, Mary Replogle Austin, Lela French, Florence Ockerson, Clara Carey, Laura Gregg, Leah Gasner, Leola Shank, Guy Byrkit, Hallie Blood, Gerlie Lockart, Cora Stockaleger, Mary Godfrey, Maud Pomeroy, Claud Bishop, Louie Stephenson, Laura Bell, Grace Butterfield, Paul Richards, Wallie Shank, S. Beerman, F. Raymond, Darwin Merritt, David Thomas, Harry Brown, A. Reed, David Reed, Will V., Will Auilin, Gordon Hayes, and Harry Barnes.

Opened in 1909, the Beardsley Theater was equipped with the finest appointments that could be found. It replaced the Rynearson Opera House as the theatrical center for drama. The Rynearson was built in 1876 and was considered too out of date, so it was closed when the Beardsley opened. Rynearson still stands today, but the Beardsley burned in 1932.

Ted Charles and Arnold Samuelson owned Samuelson's Cigar Store. It was so named because Arnold's mother could not abide the idea of a pool hall. It was located at 218 Coolbaugh Street. In 1934, Arch Breeding was a janitor here, and one night he took a revolver from Joe Samuelson's desk and shot his wife with it. (Courtesy of Winn Samuelson.)

Alix, pronounced "a-lix," was the most remarkable horse of her age. She was named queen of the turf when she broke all records; her racing time was 2:0375. Her record held through the rest of her life. Carl Sandburg wrote a poem called "Sweet Little Alix." Pactolus Park was built to showcase the horse.

Hawkins Park, about four miles south of Red Oak, was a place for fun, horse racing, and later car racing.

www.arcadiapublishing.com

MAP SEARCH

Discover books about the town where you grew up, the cities where your friends and families live, the town where your parents met, or even that retirement spot you've been dreaming about. Our Web site provides history lovers with exclusive deals, advanced notification about new titles, e-mail alerts of author events, and much more.

MADE IN THE USA

Arcadia Publishing, the leading local history publisher in the United States, is committed to making history accessible and meaningful through publishing books that celebrate and preserve the heritage of America's people and places. Consistent with our mission to preserve history on a local level, this book was printed in South Carolina on American-made paper and manufactured entirely in the United States.

This book carries the accredited Forest Stewardship Council (FSC) label and is printed on 100 percent FSC-certified paper. Products carrying the FSC label are independently certified to assure consumers that they come from forests that are managed to meet the social, economic, and ecological needs of present and future generations.

FSC
Mixed Sources
Product group from well-managed forests and other controlled sources

Cert no. SW-COC-001530
www.fsc.org
© 1996 Forest Stewardship Council

Find Your Place in History.